Illuminated Manuscripts of Germany and Central Europe

IN THE
J. PAUL GETTY
MUSEUM

Illuminated Manuscripts of Germany and Central Europe

IN THE
J. PAUL GETTY
MUSEUM

Thomas Kren

THE J. PAUL GETTY MUSEUM
LOS ANGELES

Dominica prima in adventu dni Introitus

mam meam deus meus inte con
fido non erubescam neq; irrideat
me inimicus meus etenim vniversi q

Foreword

This third volume in the popular series about the J. Paul Getty Museum's highly regarded collection of illuminated manuscripts introduces German book illumination from the Middle Ages. While American museums often favor the French and Italian traditions, the art produced in Germany and Central Europe represents one of the great achievements of the medieval era. The Getty Museum's thirty-two manuscripts from this region, a substantial holding, are representative of the diversity of the area's production. From a Carolingian Gospel lectionary, written in gold and silver on purple parchment in the ninth century, to an elaborately illustrated family history compiled over nearly ninety years, from 1626 to 1711, this volume reveals the central role of manuscript illumination in the art and culture of Germany and Central Europe. Especially well represented are liturgical books from the Ottonian and Romanesque eras, when German manuscript illumination was in its fullest flower. Two of the masterpieces of the collection are the twelfth-century liturgical books from the Benedictine monasteries of Hildesheim and Helmarshausen in Lower Saxony, both leading centers of artistic production. Other gems of the collection include thirteenth-century psalter illumination from Würzburg; the most richly illuminated surviving copy of Rudolf von Ems's popular *Weltchronik* (World Chronicle), from about 1400–1410; and the only known illuminations by the Master of Saint Veronica, a beloved Cologne panel painter, from around the same time.

I am grateful to the many Getty staff members and others who contributed to the publication. Thomas Kren, Senior Curator of Manuscripts, who has been responsible for the development of the manuscripts collection since its establishment in 1983, compiled this volume. Jeffrey Hamburger, William Diebold, and the Manuscripts Department curatorial staff members Christine Sciacca, Kristen Collins, Elizabeth Morrison, and intern Henrike Manuwald have all contributed valuable information and suggestions to the author. The Museum's Imaging Services Department, in particular Stanley Smith, Rebecca Vera-Martinez, Michael Smith, and Chris Allen Foster, worked diligently to create the beautiful images in these pages. Patrick Pardo, John Harris, Jesse Zwack, Robin Ray, Jeffrey Cohen, Amita Molloy, Karen Schmidt, and Deenie Yudell of Getty Publications all made essential contributions to bringing the book to life.

Michael Brand
Director

INTRODUCTION

Dagulf, a scribe at the court of Charlemagne (r. 768–814),
urged that the Word of God be written using the most precious materials: "Golden
words resound.... Behold the golden letters paint David's psalms. Songs like these
should be ornamented so well. They promise golden kingdoms and a lasting good
without end." Dagulf's enthusiasm for "golden words" may sound strange to the modern
ear, but it reflects a medieval view of Christian texts that gave a powerful impetus to
the art of the illuminated book even before Dagulf's time. The use of precious materials
to underscore the sanctity and spiritual promise of the Word of God was widespread
in the Carolingian era (ca. 750–900), of which Charlemagne's rule was an early and
glorious stage. It was judged only fitting to record the sacred texts in gold and silver, with
the initial letters turned into fanciful creations with a life of their own. This aesthetic
remained a powerful force in German manuscript illumination for centuries, through
the High Middle Ages.

This essay introduces the collection of medieval manuscript illumination from
Germany and Central Europe assembled by the J. Paul Getty Museum and considers
the works roughly chronologically within the region's evolving traditions of manuscript
painting. It is not an exhaustive history of this illumination or even a balanced survey,
but an endeavor to consider the Getty manuscripts within their historical framework
and also to introduce a great artistic tradition to a wider audience. The Getty Museum's
collection is rich and varied in its representation of epochs, regions, and book types, and
it contains half a dozen works that may be judged among the most important examples
of German and Central European manuscript illumination in the world.

During the reign of Charlemagne, the first important centers of book produc-
tion were established in the broad area where Germanic languages were widely spoken
in the Middle Ages (such as Germany and the adjoining regions of Switzerland, Austria,

and Poland). Charlemagne, the Frankish king who was crowned emperor by Pope Leo III in A.D. 800, set out to establish a "new Rome" at his favorite residence, Aachen (Aix-la-Chapelle), and, among other things, commissioned books that would reflect its glory. Over a period of decades, an ongoing program of reform in culture and learning enabled book-production centers, called scriptoria, to flourish.

Court reforms resulted not only in the collection, transcription, and editing of numerous valued texts but also in the introduction of Caroline minuscule, a new script designed to impose regularity and uniformity on writing. The qualities of order and uniformity in the new letter forms were in part a reflection of the philosophy behind the emperor's revival of learning; due to their marvelous clarity, certain features of Caroline minuscule persist even today in modern typefaces. Indeed, the principle of legibility in writing was extended to the articulation of the page and the presentation of texts. Improvements were also made in the Carolingian liturgy, the rite of public worship; liturgical service books, including the sacramentary (the prayers recited by the priest in public worship) and the Gospel lectionary (the Gospel readings arranged according to the church year), came into wider use. Schools were set up not only at the imperial court but also at monasteries throughout the realm. A number of the monasteries, such as Saint Nazarius at Lorsch in Germany (pp. 38–39), Saint Gall in Switzerland (pp. 40–42), and Saint Martin at Tours in France, became important centers of book production. Within this burgeoning artistic and intellectual culture, the attitudes expressed by Dagulf continued to enjoy respect and adherence.

While the Getty collection lacks a Carolingian manuscript with pictures (called miniatures), it owns two exceptional books from the period that reveal much about the aesthetic and spiritual values of Carolingian culture (pp. 36–39). The earliest is an illuminated Gospel lectionary datable to the beginning of the ninth century. It is both a *codex purpureus* (purple book) and a *codex aureus* (golden book), which were two of the most prized categories of luxury book. A *codex purpureus* is a manuscript with splendid purple leaves (p. 36) while the *codex aureus* is a manuscript sumptuously written in gold (p. 37). Despite these costly features, the Getty's manuscript is otherwise decorated quite simply; every page has a full border that forms a rectangular frame, usually in sienna or gray-blue, embellished with a simple pattern, and edged with thin

gold lines, the whole about ⅜ inch (9.5 mm) wide. Many of the pages also have beautiful decorated letters in gold. (The script is written in gold with an apparent admixture of bronze powder, which over the centuries has caused some of the letters to take on a greenish cast.)

The Getty manuscript opens with four leaves dyed or painted purple. Purple pages belong to a tradition associated with rulers of the ancient Roman Empire. In creating his court and establishing its traditions, Charlemagne drew extensively upon the examples of imperial Roman art, politics, and culture, so the meaning of the purple pages would have been clear to his contemporaries. Indeed, by the ninth century, wealthy and prominent individuals who were neither kings nor emperors might own books with purple leaves, as was likely the case with this manuscript.

Dagulf probably had in mind the genre of *codex aureus* when he praised the writing of biblical texts in gold letters. The Gospel lectionary, a type of book that was popular throughout the Middle Ages, presents the writings of the four evangelists Matthew, Mark, Luke, and John not in their original narrative order but excerpted and rearranged to be read aloud as part of worship services. Both books and literacy were exceptionally rare at this date, and church services were then, as they are now, organized around the spoken word. The readings from Gospel lectionaries, together with prayers and recitations from other service books (such as the sacramentary), served the enduring oral tradition of Christian communal observance. Under the Carolingians, by the mid-ninth century, Gospel lectionaries were widely available within the realm, even at parish churches.

The Caroline minuscule of the Getty manuscript exemplifies the clarity and uniformity sought in the reformed script mentioned above. Indeed, one of this book's scribes was trained at the court of Charlemagne and served as a scribe for the *Libri Carolini* (Caroline Books), a famous text written for Charlemagne. The patron of the Getty manuscript was likely a high-ranking member of the Church.

Another type of book, the Gospel book, was often produced as a luxury volume for Carolingian patrons. It, too, contained the texts of Matthew, Mark, Luke, and John, but this time in their entirety and in their traditional sequence. An example produced at the Benedictine monastery of Saint Nazarius at Lorsch also illustrates the role of the

reformed script in the service of the Word of God (pp. 38–39). It was written a generation or two after the Gospel lectionary discussed above, between 826 and 838. The opening words, or *incipit*, of the Gospel of Saint Matthew are written in capital letters inspired by ancient Roman inscriptions carved in stone (p. 39). These few introductory words are given their own page and are executed in gold, a distinction not conferred on the balance of the text. The Gospel texts themselves are preceded by canon tables, a concordance of numbers (in Roman numerals) designed for locating parallel narratives within two or more Gospels (p. 38). The columns of numbers are framed by architectural columns and round arches, inspired by ancient building styles. The monastery of Saint Nazarius was the site of an important library as well as a scriptorium that produced books for prominent clerics and other officials. It enjoyed strong ties to the emperor's court throughout the ninth century. Charlemagne had gathered brilliant minds around him, saw to their proper training, and sent them to serve throughout the realm, often as abbots and bishops. According to an inscription, the Getty Gospel book was written for Folcwich, bishop of Worms (826–837), just west of Lorsch, and the text was written out by a monk named Vahlram.

The succession of emperors named Otto lent their name to the epoch that succeeded that of the Carolingian rulers. The Ottonian rulers (919–1024) were great patrons of manuscript illumination and of the monastic centers that produced them, hewing closely to the Carolingian tradition that they held in high esteem. Charlemagne patronized monasteries as centers of book production but also had a court school. The Ottonian court, on the other hand, was itinerant and traveled among the monasteries that produced their books. This period saw an ever-increasing demand for expensively illuminated liturgical books, including mass books such as Gospel lectionaries, sacramentaries, and benedictionals. Indeed most of the illuminated manuscripts produced in the Ottonian era were liturgical in character. The practice of glorifying biblical texts with splendid calligraphy, sometimes in gold and silver, and with sophisticated painted letters, continued to be important. Artists of the day sometimes gave such free rein to their imaginations that their decorated letters became almost indecipherable (p. 48). But by the end of the tenth century, we see in the decorated letters of an Ottonian Gospel lectionary in the Getty collection much greater clarity and legibility

(pp. 40–42). It was created either at the monastery of Reichenau, a particular favorite of the Ottonian imperial patrons that was located on an island at the western end of Lake Constance close to the modern German border with Switzerland, or at the monastery of Saint Gall, on the Swiss side of the border to the southeast. The first word in the opening for the Gospel reading at Pentecost, *SI* (*Si quis diliget me*; "If anyone loves me"), receives a full page with a framing double border (p. 41). The *S* features interlaced acanthus vine scrolls, a motif from classical antiquity, which the Ottonians, like their Carolingian forebears, continued to emulate. Characteristic of this decorative style is the flattening of the gold-and-silver vine tendrils, the regularized widths of the vines, and the simple, symmetrical shape of the leaves. The initial *I*, also composed of vine tendrils, is more playful, culminating in a snake that threads itself around and through the vines. This book is richly embellished with 184 such glistening letters, four of them filling the entire page (pp. 40–42). Such books illustrate the Ottonians' elegant, inventive use of golden script to glorify the Word of God.

Many of the most beautiful and precious manuscripts and objects produced during the Ottonian era came together on or near the altar where the Mass—the liturgy of the Eucharist, when bread and wine are transubstantiated into Christ's body and blood—was celebrated. Elegant crucifixes, chalices, patens, and candlesticks would have joined liturgical books, such as the Gospel lectionary and the sacramentary. The most splendidly illuminated pages of the latter were those connected with the Canon of the Mass. In one opening of a sacramentary, probably made at Mainz, the left-hand page shows the Preface to the Canon of the Mass (p. 48). The *VD* monogram of the first words of the Preface (*Vere dignum*, "Truly deserved") is a dense composition of scrolling and intertwined vines of gold leaf, whose center forms a subtle, elegant cross. The remaining text is written in gold against a sumptuous background of royal purple. The right-hand page (pp. 13 and 49) illustrates the opening of the Canon of the Mass (*Te igitur*, "You, therefore (most merciful Father)") with an image of Christ in Majesty, rather than the more typical Crucifixion. Christ is shown within a mandorla, regally seated upon the arc of heaven, his feet resting upon the world. This subject, which shows Christ as judge, is appropriate to the Canon because the celebration of the Eucharist prepares the communicant for Christ's second coming and the Last Judgment. It is

derived from Saint John's vision of the end of time, as recorded in the New Testament book of Revelation, when Christ returns to judge all mankind.

While the literal embellishment of the sacred text itself was an essential component of German manuscripts from the eighth to the eleventh century, narrative and iconic imagery had formed another significant feature since the Carolingian era. During the Ottonian era, liturgical ceremonies of an increasingly elaborate character may have encouraged the taste for powerful narrative images from the Gospels within illuminated books. The sacramentary from Mainz contains a prefatory cycle of six full-page miniatures relating key episodes from the life of Christ (pp. 46–47). With figures featuring expressive eyes, large hands, and dramatic gestures, these images show Ottonian illumination as a wondrous narrative art. The meaning of the stories is further underscored by the complete focus on the figures, with backgrounds reduced to beautiful but static bands of flat color.

The cover of the Mainz sacramentary is not original and was likely assembled from fragments of different liturgical and devotional objects of the medieval era; nevertheless, it reflects the practice of embellishing such precious books for the Mass with costly bindings that combined metalwork (gold, silver, and/or bronze), with jewels and other precious materials (this page). Such radiant covers, sometimes called treasury bindings, were admired in their day every bit as much as the illuminated pages, by many accounts more so. The books themselves would have been kept not in the library of the monastery but either closed on the altar or stored in the church's treasury with other valuable liturgical objects. A note inserted into this sacramentary in the early twelfth century states that the book was given by the Benedictine abbey of Saint Albans in Mainz, under the rule of Archbishop Bardo (1031–51), to the abbey of the same name in Namur (in modern Belgium), around 1055, not long after its founding, along with some relics of Saint Albans.

Book cover for a sacramentary; Mainz or Fulda, ca. 1025–50; Ms. Ludwig V 2 (83.MF.77)

Another liturgical book, the benedictional, contains the blessings that a bishop would recite during

the Mass (pp. 43–45, back cover). A key miniature in the Getty's Ottonian benedictional actually shows the book's recipient, Bishop Engilmar of Parenzo (modern-day Poreč, northwestern Croatia), before the altar offering a blessing (p. 43). The altar shows a communion chalice and paten along with another mass book, probably a sacramentary. Engilmar became bishop in 1028 and during the 1030s was a guest of the Benedictine monastery of Saint Emmeram in Regensburg. (While there, it is said he was cured of a malady by the waters of the cloister's fountain.) This book was probably made at Saint Emmeram at that time. Regensburg, the capital of Bavaria, enjoyed tremendous prosperity throughout the century and a privileged position under the Ottonian emperor Henry II (r. 1002–24), who briefly made the city his capital and lavished patronage on the monasteries, especially the scriptorium at Saint Emmeram. The latter became one of the finest centers of manuscript illumination during his reign. Like the Mainz sacramentary, the Getty benedictional contains a cycle of full-page miniatures of Gospel stories. While the six miniatures of this type are grouped together toward the front of the Mainz sacramentary, the eight in the benedictional are distributed throughout the book, where they illustrate the episcopal blessings for major feasts of the church year. The highly burnished gold backgrounds of the miniatures are a common feature in Ottonian illumination and remained popular for several more centuries.

The late eleventh and the twelfth centuries saw a revival of art and architectural forms based on ancient Roman models, which developed into a distinctive, eclectic style called the Romanesque. In Germany the Romanesque tradition enjoyed an extraordinary flowering, evidenced by new artistic centers, new book types, and new iconography. One of the most important new centers was the Benedictine abbey of Helmarshausen in medieval Saxony in the vicinity of modern-day Paderborn. Helmarshausen had been founded in 997 and enjoyed the promotion of its privileges and rights under Otto III (980–1002). However, its artistic flowering began later, toward the end of the eleventh century, under its dynamic abbot Thietmar II (r. 1080/81–1115/22), who revitalized its scriptorium, oversaw the creation of splendid examples of metalwork, and acquired costly reliquaries for its treasury. Thietmar also supported the founding of a workshop of illuminators that came to be one of the finest in northern Germany.

The Helmarshausen school of illumination specialized in brilliantly colored

Gospel books. The embellishment of the sacred words was as important in a Gospel book as the inclusion of figural images. The Getty collection's Gospel book from Helmarshausen, probably produced during the 1120s, is one of the masterpieces produced there and a paragon of its early mature style. It contains sixteen illuminated canon tables (pp. 50–51), four portraits of the authors writing their texts (p. 52), and four full pages of decorated text (p. 53), each representing the *incipit* of one of the Gospels. In the depiction of Saint Matthew at his desk, as with the other evangelist portraits, the illuminator gives the figure weight and substance, even though the evangelist sits before a flat backdrop of highly burnished gold leaf (pp. 16, 52). The folds of the drapery are organized into patterns of nested elliptical contours or V-shapes. They highlight the powerful human form beneath the garments, so that the figure of Matthew appears both dynamic and monumental. Ancient Roman art continued to find an echo in German art, as is apparent in the full border of rhythmically arranged acanthus leaves, a favorite decorative motif in antiquity. The entire page is composed of interlocking and overlapping areas of brilliant color and pattern, each with sharp, clear contours; for example, the divine labor of Matthew's hands is set off against the gold ground. It is a design of exceptional intricacy overall, with some areas densely patterned, such as the acanthus leaves and the cushions of Matthew's stool, and others plain, such as the rectangle of gold leaf in the center. At the same time it is entirely harmonious. The brilliant orchestration of form and color, which is so varied and often of a remarkable purity and luster, remains very appealing to the modern eye.

No less extraordinary are the full-page illuminations of the opening words of the Gospel that face each evangelist portrait in the Helmarshausen manuscript. Saint Matthew is shown writing the lines, with pen and sharpening knife in hand, that appear on the facing page: *Liber generationis jesu christi filii David filii habrah*[*am*] (The book of the generations of Jesus Christ son of David son of Abraham). The letters *LI*, intertwined and composed of spiraling vines of gold and silver leaf, are set against a lush ground of lapis blue that also follows the outer contours of the entwined initials (pp. 7, 53). These letters and the successive ones on the page, in alternating gold and silver, rest on an elaborately patterned backdrop of pale purple, probably inspired by Byzantine silk textiles, to which the German nobility had enjoyed access since at least

972, when Otto II (955–983) married the Greek princess Theophanu. German illuminators continued to find highly varied new uses of gold to embellish sacred texts. They also sought to brighten—the original sense of the Latin verb *illuminare*—the page in other diverse and imaginative ways, thereby enriching the qualities of costliness, luxury, and sanctity.

Scholars have noticed parallels between the Helmarshausen Gospels and the metalwork associated with Roger of Helmarshausen, a monk of the abbey and one of the finest metalsmiths of the Middle Ages. The figure of the angel (the symbol of Saint Matthew) in the canon tables (p. 50) recalls closely an angel on the exquisite gold cover to a Gospel book, one of the masterpieces of German Romanesque metalwork, that resides in Trier (this page). The clarity of form, rhythmic contours, and pose are common to the angel in both the book cover and the canon table.

Medieval Saxony was the home of another important school of Romanesque manuscript illumination, this one based in Hildesheim. The Benedictine monastery of Saint Michael was established during the Ottonian era by Saint Bernward, the visionary bishop of Hildesheim from 993 until 1022 (p. 63). A member of the chancellery and chapel at the imperial court, Bernward made Saint Michael's a center of patronage of the arts, including manuscript illumination along with both monumental and fine metalwork. The bronze doors of Hildesheim cathedral, which are among his most

Roger of Helmarshausen, book cover (detail), Trier, cathedral treasury, ms. 139/110/68

celebrated commissions, illustrate his astonishing ambition (p. 18). The tradition of patronage at Saint Michael's continued for several centuries after Bernward's death. Indeed, the greatest example of manuscript illumination commissioned by Saint Michael's was executed about 150 years later, during the 1170s. This is the Stammheim Missal, now in the Getty collection (pp. 54–63).

The missal, a service book, is one of the new types of books that came to be illuminated during the twelfth century. It combines the texts necessary for both the spoken and sung portions of the Mass.

Bronze doors from the monastery of Saint Michael's, completed 1015, Hildesheim, cathedral

The Stammheim Missal represents an early stage in the evolution of this new text, combining the prayers recited by the priest contained in the sacramentary with the chants found in the choir book into a single text used by the priest. Its sumptuous decoration draws upon existing traditions of the older service books while also introducing new and theologically complex subjects. In the Mainz sacramentary, the text of the *Vere dignum* prayer was richly decorated, its letters in gold, and its ground in purple (p. 48). The Stammheim Missal carries on that tradition, treating the text in an expanded format, across a two-page spread of stunning pictorial richness (pp. 58–59). Here the *Vere dignum* prayer begins with the *VD* monogram at the lower left and continues at the right in lines of different color combinations.

The backgrounds of gold, silver, black, red, and sienna are mixed variously with the script written in black, gold, and/or white. As with the Helmarshausen Gospels, which were produced by another artist in a different area of Saxony two generations earlier, the illuminator here joins a range of richly saturated, quite pure colors with diverse shapes and patterns into illuminations of a vibrant unity. This aesthetic exemplifies Romanesque style.

Historical and theological issues are fundamental to the decorative program of this book. Intellectual currents of the twelfth century sought to strengthen the connection between text and image and at the same time to enrich the character of Gospel imagery by presenting it within a dense theological framework, juxtaposing each New Testament narrative with one or more scenes from Jewish scripture. New

Testament scenes are shown as fulfillments of Old Testament prophecy, an approach called typology, which originated in the early Christian era. The heightened interest in Christian prophecy and typology in the twelfth century led to the creation of new iconography along with the depiction of many new biblical subjects, often drawn from Jewish scripture. The Stammheim Missal offers an exceptional synthesis of this theology, introducing a visual architecture that facilitates the understanding of the New Testament as the realization of events foreshadowed in the Old Testament.

In the center of the full-page miniature of the Ascension of Christ, the Virgin and Jesus' disciples look upward as Christ ascends gracefully to heaven (p. 61). Meanwhile, the four corners of the miniature present scenes of prophecy from the Old Testament for which the Ascension of Christ represents fulfillment. At the upper right, for example, a chariot of fire carries the Old Testament prophet Elijah to the firmament, while at the lower right Enoch, after having lived 365 years, also rises heavenward as described in the book of Genesis (5:21–24). In keeping, too, with the hierarchy of meaning and importance, the figures from the Gospels are larger and at the center, while the smaller Old Testament prefigurations occupy the periphery. The importance of the biblical texts for understanding this mosaic of interlocking images is underscored by the banderoles (or scrolls) and other inscriptions that contain pertinent passages from both the Old and New Testaments. Biblical storytelling is thus organized into a scheme that reveals theological content. Prophets from Jewish scripture (p. 57) and allegorical figures (pp. 57–59) are distributed generously throughout the illuminations. Despite the complexity of thought and narrative, the artist lent the illuminations visual coherence and authority through the structured geometry of the pages. These large miniatures invite both close and repeated viewing. This sort of typological representation is a landmark, establishing a dense, complex pictorial tradition that was widely influential and underwent periodic revivals into the sixteenth century.

Another powerful group of images in the Stammheim Missal centers on the depictions of individual saints. While the representation of saints in large miniatures was not new in the twelfth century, its importance was rapidly growing. In the Stammheim Missal we find a spellbinding full-page miniature of Saint Michael defeating the devil in the form of a dragon, in the final battle before the Last Judgment

(pp. 2 and 62). The feast of Saint Michael and its large miniature are undoubtedly included to honor the monastery's namesake. Another full-page miniature shows Saint Bernward himself (p. 63). While he was not yet officially canonized when this book was made, the monks had received permission to venerate him as a saint within the monastery. He is shown with the monastery's monks, including two who are identified by name: Gevehard at the top and Heinrich of Midel kneeling at the founder's feet. They may have played a role in the book's creation as either patrons or artisans. This extraordinary range of imagery, along with its unparalleled artistry and complex theological goals, makes the Stammheim Missal one of the major achievements of German Romanesque art.

The twelfth century also witnessed the growing popularity of another genre of luxury illuminated book, the psalter, among both ecclesiastical and lay patrons. The psalter is a collection of all 150 of the Old Testament psalms, arranged for devotional purposes. King David, who was thought in the Middle Ages to have authored the psalms, generally figures prominently in psalter iconography. Illuminated luxury psalters were known as early as the Carolingian era but their greatest popularity belongs to the period of the twelfth to the fourteenth century. The Getty Museum owns a nearly complete psalter from Würzburg in Franconia and two splendid full-page miniatures that once belonged to another lavish psalter, also from Würzburg (pp. 70–76 and 67–69). Both date from the mid-thirteenth century.

Traditionally, the grandest opening of a psalter is the *Beatus* page, which illustrates the first letter of the first words of Psalm 1 (pp. 21 and 74–75). It features a full-page initial *B* that is usually illustrated with King David. In this example, David is playing his harp with his musicians in the lower bulb of the *B* while a seated blessing Christ appears in the upper portion. The *B* is enveloped in swirling vines, out of which other figures and animals emerge against a background of gold leaf, now partially abraded. Still more dramatic, however, is the facing page, on which the opening words of the first psalm appear in grand uppercase letters (p. 75): [B]EATUS VIR QUI NO(N) ABIIT IN COSI (The blessed man who has not walked...). The golden letters, executed in hammered and burnished gold leaf, occupy a sort of checkerboard in which each square is defined by thick bands of gold leaf and the backgrounds are combinations of blue

and dull burgundy, divided in halves or quarters. This text page is as sumptuous as the two-page openings with the evangelists in the Helmarshausen Gospels (pp. 52–53).

The importance attached to Jewish scripture as the prefiguration of Gospel events is underscored in this psalter in several ways. Figures of the prophets appear in the Würzburg psalter in diverse contexts, with large figures of Old Testament prophets in the book's calendar of feasts of the church but also in full-page miniatures on their own (pp. 70–71, 73, and 76). Prophets sometimes appear opposite narrative scenes drawn from the Gospels. For example, the miniature of the Nativity is paired with a miniature of the prophets Habakkuk and Isaiah (pp. 72–73). Isaiah holds a scroll that contains a verse from his Old Testament book, "For a child is born to us and a son is given to us" (Isaiah 9:6), which was understood by Christians to allude to the mystery of Christ's birth. Also featured in this psalter are typological pairings of Old Testament subjects, such as *The Tree of Jesse* (p. 71), mentioned in the book of Isaiah (11:1–4), with *The Annunciation* of the New Testament. Following the didactic model of juxtaposing Old Testament with New Testament themes, seen previously in the Stammheim Missal, the annunciation of the birth of Christ on earth is presented in the psalter as a fulfillment of the Jewish scriptures: it was understood that Jesus was descended from the Old Testament figure of Jesse.

The two leaves from another psalter made in Würzburg belong to a different type of cycle, one that was also popular in luxury devotional books (pp. 67–69). While the full-page miniatures in the psalter discussed above are organized into a program that stresses the relationship of the Gospels to Jewish scripture, these two leaves belong to a cycle depicting the life of Christ, including his infancy and Passion. Twenty-three full-page miniatures from the cycle are known from a series that may have numbered as many as thirty-two. Called a prefatory cycle, the series would have been placed before the beginning of the psalter; while the Old Testament psalms played a central role in Christian devotion, they were always in the service of the Gospel message. *The Annunciation* and *The Adoration of the Magi* are two of the most beautiful and meticulously rendered among the miniatures. With their highly burnished backgrounds of gold leaf, both focus on the figures. The mantle of the angel Gabriel in *The Annunciation* is articulated in dense angular folds with highlights that play like lightning across the surface and

lend drama to this momentous subject. The jagged contours of drapery, often gathered densely as in Gabriel's robe and mantle, are a characteristic of much German illumination of the thirteenth century and have given rise to the German term *Zackenstil* (or "zigzag" style). Similar angular contours are apparent in the robes of figures in the other psalter from Würzburg (pp. 70 and 76).

In the thirteenth and fourteenth centuries, Switzerland continued to be an important region for luxury manuscript production. Another psalter in the Getty collection was produced at the Benedictine abbey of Engelberg, in central Switzerland, probably during the abbacy of Walter of Yberg in the third quarter of the thirteenth century (p. 77). Engelberg was a double cloister, a distinctive type of organization that grew out of church reforms of the eleventh and twelfth centuries. Under the rule of a single abbot or abbess, the double cloister joined a monastery (for monks) and a convent (for nuns), which were usually situated near one another. Engelberg was one of the most successful of these. The Getty Museum also owns a charming historiated initial removed from a splendid Gothic gradual (Nuremberg, Germanisches Nationalmuseum) that was likely produced for the wealthy Dominican convent called Katharinenthal in the area of the Upper Rhine in northeast Switzerland (p. 78). It shows the infant Saint John the Baptist offering a red crown to the infant Jesus. The boys are accompanied by their mothers, Elizabeth and Mary, respectively.

For the works discussed heretofore, what limited evidence we have of patrons and early owners of the books in the Getty Museum's collection has pointed overwhelmingly to male ecclesiastics. The Lorsch Gospels were made for the bishop of Worms and the benedictional for Bishop Engilmar of Parenzo; the sacramentary from Mainz had been presented by the early twelfth century to the abbey of Saint Albans in Namur, and the Stammheim Missal was made for Saint Michael's monastery in Hildesheim. However, women also played a prominent role as patrons of books, often in their capacities as consorts of rulers or as abbesses of important convents. Furthermore, convents as institutions were often important patrons for a wide range of liturgical books and objects in the Middle Ages. Katharinenthal was a tremendous source of artistic patronage from the late thirteenth century, including not only illuminated manuscripts but also a great many devotional objects of exceptional quality, such as polychrome sculptures,

metalwork, and textiles. While psalters usually had a liturgical function—monks and nuns used them to recite their daily round of devotions—in the twelfth and thirteenth centuries they were also increasingly popular among laywomen, who showed a particularly strong interest in books for personal devotion. While we do not know who originally owned either the psalter or the loose psalter miniatures from Würzburg in the Getty collection, an inscription on the back of one leaf of the latter indicates the book's earliest known owner, who lived in the late sixteenth century. She was Elizabeth Kögl, mother superior of a German convent.

Women also played important roles as religious leaders in the reforms of the twelfth and thirteenth centuries. An important example is Saint Hedwig (1174–1243), duchess of Silesia (in Poland on the modern border with Germany), a great supporter of the monastic movement. After bearing Henry I of Silesia seven children, and even before her spouse's death in 1238, she retired to the Cistercian convent of Trebnitz that she herself had founded (p. 85). In recognition of her contribution to the faith she was canonized in 1267, remarkably soon after her death. Her extraordinary life as well as its dynastic and spiritual importance is recounted in a luxurious copy of her canonization dossier commissioned by her descendants, Duke Ludwig I of Liegnitz and Brieg (d. 1398) and his wife, Agnes of Golgau, in 1353 (pp. 82–85), and donated to the convent of Saint Hedwig in Brieg. One of the masterpieces of Silesian medieval art, *The Life of the Blessed Hedwig* (*Vita beatae Hedwigis*) features as its artistic centerpiece the stunning cult image of Hedwig, wearing a widow's veil and clutching her open prayer book, a rosary, and a devotional statuette of the Virgin and Child (pp. 82–83). Hedwig is also shown barefoot, holding her boots, because she walked barefoot in the snow in emulation of Christ's suffering (p. 84). Besides her asceticism, she was known for her concern for prisoners and the sick; among her acts of charity was the founding of a leper hospital.

The thirteenth and fourteenth centuries witnessed dramatic political, economic, and cultural developments that open up new chapters in the story of German and Central European manuscript illumination. Older cities such as Cologne—the largest in medieval Germany—grew in wealth and power while other towns emerged as major centers, such as Prague and Vienna, which established their own universities in

the fourteenth century. Cologne continued to enjoy considerable prominence for its art production, while Prague developed into one of the chief art centers of Europe. This era also saw a rapid rise in the demand for texts written in the vernacular (the spoken language of a region, such as English, French, or German), along with a tremendous increase in secular texts. Many were transcribed in luxurious illuminated copies. Moreover, a new aesthetic was apparent already in the Hedwig codex. The representation of the human figure and of the space it inhabits gained in verisimilitude and volume. Artists endeavored to record more directly and accurately the colors and textures that they observed in the natural world and their surroundings. The enduring role of gold in the art of illumination evolved, too. Its application remained widespread but in more subtle ways and sometimes with a smaller role overall within an image or on a page. Occasionally, as in the Hedwig miniature, gold is omitted altogether (pp. 82–83). Overall, the types of manuscripts being produced and the range of illumination styles continued to broaden.

The artistic patronage of the Holy Roman emperor Charles IV (1316–1378) reshaped the city of Prague through the construction of a new cathedral (Saint Vitus), a new castle (the Hrad), and other important buildings. His largesse made his court one of the most splendid in Europe and an important and influential center for artistic production, including manuscript illumination. The richly and subtly painted drapery, the facial types, and the elaborate architectural settings in the miniature of Saint Hedwig call to mind the art of the Bohemian capital of Prague under Charles IV. The attention to detail, the full modeling, and the gentle sway of the figure reflect an entirely new aesthetic of the Bohemian court that scholars call the "Beautiful Style." The figure of Saint Hedwig, for example, stands in contrast to the figures in the Würzburg psalters in the level of detail and the richness of modeling (pp. 82–85 and 67–76).

The arts continued to flourish under Charles's son, Wenceslas IV (1361–1419), king of Bohemia. An elegant example of the "Beautiful Style" is a group of miniatures removed from an antiphonal, a book containing the music sung by the monks during their daily cycle of prayer (pp. 96–97). The miniature of Saint Stephen from the antiphonal reflects the courtly naturalism seen in the miniature of Saint Hedwig, manifest also in the sinuous S-shape of the saints' postures (pp. 96 and 82). The exotic golden

birds that fill the background behind Saint Stephen reflect the taste for lush decorative pattern and richly saturated color that is found not only in Prague around this time but also in the art of Vienna, Cologne, Paris, and northern Italy. The influence of the Bohemian art of Prague, remarked in the Hedwig miniature, was felt throughout Central Europe well into the fifteenth century. An illuminator trained in Bohemia, for example, was likely responsible for the monumental *Crucifixion* in a missal illuminated in Vienna around 1420–30 (p. 98). The tall proportions, the courtly S-curve of the Virgin's pose, the soft modeling of her blue mantle, and the background richly tooled in gold filigree reflect this illuminator's Bohemian heritage.

Throughout much of the German-speaking lands and Central Europe, the fourteenth century witnessed a rise in the quality and quantity of the production of panel paintings, both as altarpieces and as devotional images. Their liturgical and devotional functions complemented the role that images played in illuminated service and devotional books. Not surprisingly, the two often had both an aesthetic and practitioners in common: artists of the Middle Ages were frequently masters of more than one art form. A major painter from Cologne, known today as the Master of Saint Veronica after one of his works on panel, also painted two of the most beautiful illuminations on parchment of the early fifteenth century (pp. 26 and 94–95). Dating earlier than the Vienna *Crucifixion,* this painter's *Crucifixion* shows a similar interest in the emaciated flesh of Christ and in richly modeled draperies, but the Cologne miniature injects an element of tenderness and pathos in the swoon and sorrowful expression of the Virgin. The accompanying miniature shows Saint Anthony, attired in the habit of the Order of Hospitallers of Saint Anthony (the Antonines) but wearing fashionable shoes (p. 95). His coat bears the Tau cross of the order, and the leaves probably come from a book or diptych intended for the followers of Saint Anthony at Cologne. Their ministry was dedicated to caring for the sick and infirm, and they ran both an important hospital and a church in the Rhine city. A splendid mid-century Bible from Cologne shows the influence of the style of another great painter of the city, Stephen Lochner, who also illuminated manuscripts (pp. 101–105).

While the production of secular texts as well as new texts written in the vernacular had already begun to accelerate in the thirteenth century, the Getty collection

represents them best from the fourteenth century onward (pp. 81, 86–93, 106–8, 112–13, and 114–15). The extremely influential *Historia Scholastica* (Scholastic History) by the Parisian theologian Petrus Comestor (d. 1178) interweaves biblical history with ancient Roman history. The Getty owns a handsome copy from Austria, about 1300, which is illustrated with small historiated initials (pp. 79–80). Histories that combined stories from sacred texts with events from broader history grew rapidly in popularity throughout Europe from the thirteenth to the fifteenth centuries, especially at the courts where deluxe illuminated copies enjoyed favor. In Germany, Comestor's text provided inspiration to Rudolf von Ems, a prolific author at the Hohenstaufen court, who wrote the *Weltchronik* (World Chronicle) around the middle of the thirteenth century. Composed in Middle High German in rhymed couplets, the *Weltchronik* combines Old Testament narratives of Moses, Abraham, David, Solomon, and others with events from the lives of prominent men of antiquity such as Alexander the Great, the Roman emperor Nero, and the philosopher Seneca (pp. 29 and 86–93). Rudolf composed this book for King Conrad IV (1228–54), using history to justify Hohenstaufen dynastic ambitions at a time of conflict with the Church. The Getty copy was produced at the beginning of the fifteenth century, when the text remained tremendously popular, and many copies were abundantly illustrated. As is the case with the Getty manuscript, many of these copies combined Rudolf's world history with other examples of the genre in the vernacular, including the *Lives of Job, Alexander, Ezechias, Eraclius, and Nero*, excerpted from Jansen Enikel's *Weltchronik*. With 370 miniatures, the Getty Museum's is the most elaborately illuminated known copy of Rudolf's text and arguably the most beautiful. Its artists found ways to insert their vigorously painted, psychologically charged miniatures wherever they could, especially in the margins. The opening miniature shows that the book was made for a noblewoman; from her exquisite gown it is clear that she occupied an elevated place in society (p. 86–87).

The illuminated manuscripts discussed until now were all produced with the most expensive pigments and written on parchment, a material produced from the skins of calves, sheep, or goats. The production of a manuscript was thus both labor intensive, since even the skins took a great deal of time to prepare, and extremely costly in materials. However, by the end of the fourteenth century, the increasing availability of

paper, initially imported from Italy, facilitated the production of a new kind of illuminated book, often decorated as profusely as in the past, but with a very different aesthetic. The pigments used on paper are similar but usually fewer in number and applied more thinly, in a dilute medium, so that the illuminations often resemble pen-and-colored-wash drawings. These books also usually lack gold, silver, or pigments made from the most precious materials, such as lapis lazuli, a lustrous mineral used for the brightest blues. Presumably, such books were much more affordable than the earlier models; they certainly enjoyed tremendous popularity throughout the fifteenth century and they survive in great numbers. Although a wide variety of titles were produced in this way, secular texts enjoyed particular favor, and the Getty collection represents them well.

A superb example is the elaborately illustrated copy of Rudolf von Ems's *Baarlam and Josaphat,* originally written in the 1220s in Middle High German (pp. 106–8). This copy was produced in 1469 in the prolific workshop of Diebold Lauber in Haguenau, which specialized in illustrated books on paper. Its 138 miniatures in ink-and-colored-wash technique make it the only fully illustrated copy of this text, which had remained popular since the time it was written. The colors employed are few, primarily green and red, with blue, yellow, and gray as well. Yet the crisp drawing and handsome, psychologically engaged figures drive the narrative forward. *Baarlam and Josaphat* is the epic story of the Buddha recast for a Christian audience. (The name Josaphat derives from Bodhisattva, one of Buddha's titles.) The story was popular across Europe and the eastern Mediterranean even before the time of Rudolf von Ems and was retold in many languages during the medieval era.

Other secular texts written and illustrated on paper included astronomical works, such as a book about the planets (pp. 114–15), and collections of animal fables (pp. 112–13), both from the third quarter of the fifteenth century. Undoubtedly the rise of printing in Germany and the rapid perfecting of the illustrated printed book there in the second half of the fifteenth century—one thinks of the Nuremberg Chronicle of the 1480s and the early books illustrated with woodcuts by Dürer—provided serious competition for manuscript illuminators by the end of the sixteenth century. Nevertheless, superb illuminated manuscripts continued to be produced in Germany into the

sixteenth century, including luxury manuscripts written on parchment and illustrated with gold, silver, and other costly pigments (pp. 116–17 and 121–23).

By the middle of the sixteenth century, the popularity of illumination had begun to diminish across Europe. Illumination workshops ceased to attract the most talented young artists, and demand was reduced. Extremely elaborate illuminated manuscripts continued to be produced in Germany well into the eighteenth century, but increasingly they were works on dynastic and military, rather than religious and literary, topics (pp. 124–27, 128, 129–31).

German manuscript illumination was one of the vital artistic traditions of the Middle Ages, a medium that continued to reinvent itself century after century, often in different centers, with new ways of illuminating, new book types to illustrate, and an ever-widening spectrum of subjects to represent. Given that this beloved tradition flourished for nearly a millennium in the German-speaking regions, it is perhaps not surprising that the art of the printed book also came to be perfected in Germany earlier than in other parts of Europe.

As is widely known today, the Getty Museum's collection of medieval and Renaissance manuscript illumination was established in 1983 with the purchase of the renowned collection of Peter and Irene Ludwig of Aachen, Germany. The collecting of the Ludwigs was uncommonly far-reaching, encompassing not only splendid manuscripts but also medieval sculpture and ivory, plus a range of works from many epochs and regions. The Ludwigs amassed entire collections of exquisite pre-Columbian artifacts and possessed major holdings in American Pop Art, as well as Greek and Roman art, Meissen porcelain, German Expressionist painting, Russian Constructivist art, and many other areas. Invariably, when they became interested in a collecting area, they purchased in depth and with great discernment.

The illuminated manuscripts, assembled over a quarter century starting in 1957, comprised one of the most thoughtfully formed of the Ludwigs' collections. It offered a microcosm of the nuanced and historically considered ways the couple

collected, covering as it did more than a thousand years and all corners of Europe. They sought to make it representative not only of the great epochs and centers but also of the myriad types of books that came to be illuminated. They bought most of their best illumination from a New York antiquarian book dealer named H. P. Kraus (1907–1988), who was the most important dealer of illuminated manuscripts of the period. Perhaps due to their own inclinations, but undoubtedly aided by the expertise of Kraus, who was born and began his career in Vienna, they were especially successful in assembling a body of German and Central European manuscript illumination from the Carolingian era to the eighteenth century. The year after they started buying manu-scripts, at the first of the famous Dyson Perrins sales (1958–60), the Ludwigs acquired the Helmarshausen Gospels, which remained one of the cornerstones of their collection as it does today of the Getty's (pp. 50–53). They notably also acquired, over the course of the next two decades, major German and Central European manuscripts from the great German, Swiss, and Austrian collections of the twentieth century, including those of Kurt Arnhold (pp. 43–45 and 70–76), Otto Schäfer (pp. 43–45, 70–76, and 101–5), Martin Bodmer (pp. 38–39, 46–49, and 106–8), Baron Rudolf von Gutmann (pp. 82–85), and Robert von Hirsch (pp. 94–95). As a result, the Ludwig's holdings of German and Central European manuscripts were the most fully formed part of their entire collection. It included well over two dozen examples from the ninth to the eighteenth century.

The Getty Museum has added highly selectively to this distinguished group by seizing opportunities to buy works that both strengthen the foundations of and add depth to the collection. Among those treasures from the High Middle Ages are the Ottonian Gospel lectionary from Reichenau (pp. 40–42), the Stammheim Missal made for Saint Michael's monastery at Hildesheim (pp. 54–63), and *The Annunciation* and *The Adoration of the Magi* from the early Gothic psalter from Würzburg (pp. 67–69). In fact, I consider the Stammheim Missal to be the greatest illuminated manuscript at the Getty and one of the greatest in any American collection; it is a landmark of Romanesque art. In terms of manuscripts from the later Middle Ages, especially noteworthy is Rudolf von Ems's *Weltchronik*, the most lavishly illustrated known copy of this tremendously popular text; the illuminations from the Bohemian choir book (pp. 96–97); and the

large *Crucifixion* that calls to mind Franconian art of the late fifteenth century (p. 116–17).

Certain American museums and their patrons have held German medieval art in high regard especially in the first part of the twentieth century. In the field of illuminated manuscripts, the Pierpont Morgan Library houses the most important collection and remains exceptional. For German and Central European medieval art in general, the collections of the Cleveland Museum of Art and the Metropolitan Museum immediately come to mind for a great variety of media, including superb manuscript illumination. The Getty Museum complements its German and Central European manuscripts largely with German and Swiss works in other media from the later Middle Ages, such as paintings by Martin Schongauer, the Master of Saint Bartholomew—also an illuminator—and Lucas Cranach; splendid drawings by Schongauer, Albrecht Dürer, Hans Baldung Grien, Cranach, Urs Graf, Niklaus Manuel Deutsch, Hans Holbein the Younger, and others; and some exceptional examples of stained glass from the fourteenth to the sixteenth century. The medieval illuminated manuscripts from Germany and Central Europe at the Getty Museum join with these various holdings to represent in considerable depth several extraordinary epochs in the history of German art.

Thomas Kren
Senior Curator of Manuscripts

Display Script and Text Page

Leaves from a Gospel lectionary,
fol. 4v–5
Rhine-Meuse region, early ninth
century
Leaf: 24.1 × 18.1 cm (9½ × 7⅛ in.)
Ms. Ludwig IV 1; 83.MD.73

IN UIGL NATALE DMI hORE NONE

SEQ SCI EUAG SEC MAT CPIII

In illo tempore cum esset desponsata mater eius maria
ioseph ante quam conuenirent inuenta e
in utero habens de spu sco. Joseph autem uir eius.
cum esset iustus et nollet eam traducere uoluit
occulte dimittere eam. Haec autem eo cogitan
te ecce angelus in somnis apparuit ei dicens.
Joseph fili dauid noli timere accipere mariam
coniugem tuam. Quod enim in ea natum est de spu sco est.
Pariet autem filium et uocabis nomen eius ihm.
Ipse enim saluum faciet populum suum a peccatis
eorum.

ITEM IN UIGL AD SCA MARIAM DE NOCTE

SEQ SCI EUAG SECD LUC CPIII

In illo tempore. exiit edictum a caesare
augusto ut describeretur uniuersus orbis.
Haec discriptio prima facta est a praeside
de syrie cyrino. et ibant omnes ut
profiterentur singuli in suam ciuitatem.
ascendit autem et ioseph a galilea de ciui-
tate nazareth in iudaeam in ciuitatem dauid quae uocatur

37

Canon Table Page

Gospel book, fol. 8v
Benedictine abbey of Lorsch,
between ca. 826 and 838
Leaf: 31.6 × 24 cm (12⁷⁄₁₆ × 9⁷⁄₁₆ in.)
Ms. Ludwig II 1; 83.MB.65

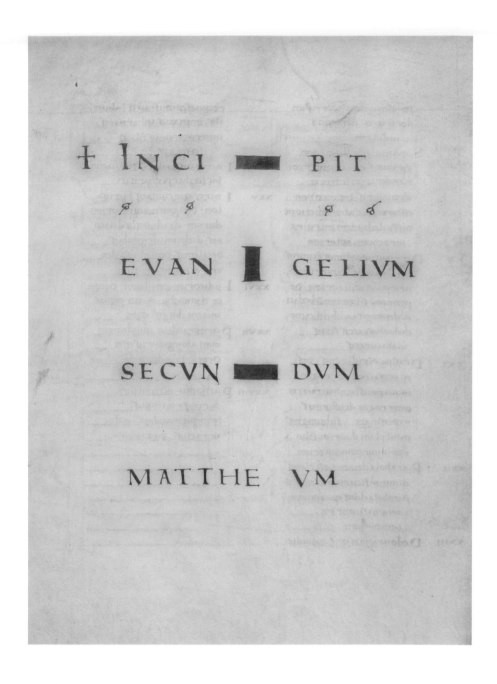

✝ INCI ▬ PIT

EVAN ▌ GELIVM

SECVN ▬ DVM

MATTHE VM

Incipit Page

Gospel book, fol. 13v
Benedictine abbey of Lorsch,
between ca. 826 and 838

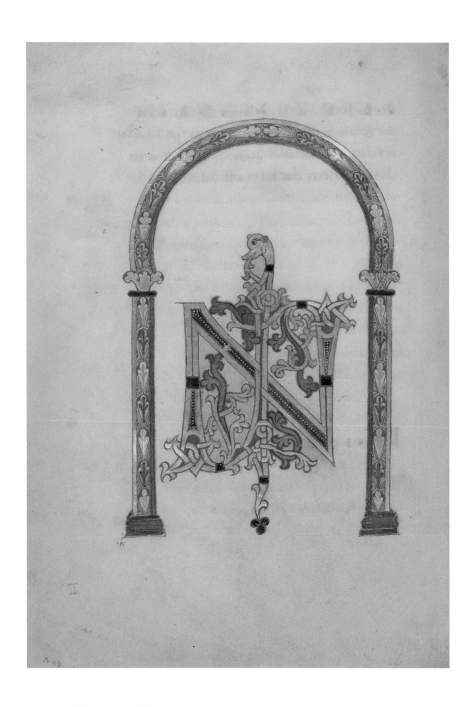

Decorated Monogram IN

Gospel lectionary, fol. 4v
Reichenau or Saint Gall,
late tenth century
Leaf: 27.8 × 19.2 cm
(10 15/16 × 7 9/16 in.)
Ms. 16; 85.MD.317

Inhabited Letters SI

Decorated Initial V

Gospel lectionary, fol. 116v
Reichenau or Saint Gall,
late tenth century

Bishop Engilmar Celebrating Mass

Benedictional, fol. 16
Regensburg, ca. 1030–40
Leaf: 23.2 × 16 cm (9⅛ × 6⁵⁄₁₆ in.)
Ms. Ludwig VII 1; 83.MI.90

The Presentation in the Temple

Benedictional, fol. 28
Regensburg, ca. 1030–40

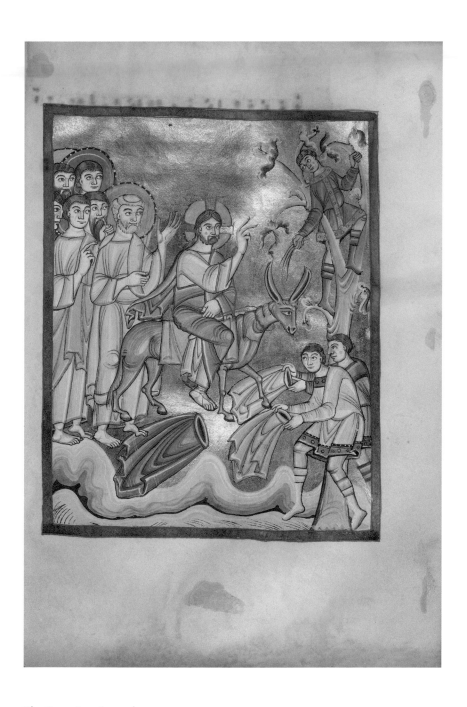

The Entry into Jerusalem

Benedictional, fol. 36
Regensburg, ca. 1030–40

The Nativity

Sacramentary, fol. 18v
Mainz or Fulda, ca. 1025–50
Leaf: 26.7 × 18.9 cm (10½ × 7⁷⁄₁₆ in.)
Ms. Ludwig V 2; 83.MF.77

The Women at the Tomb

Sacramentary, fol. 19v
Mainz or Fulda, ca. 1025–50

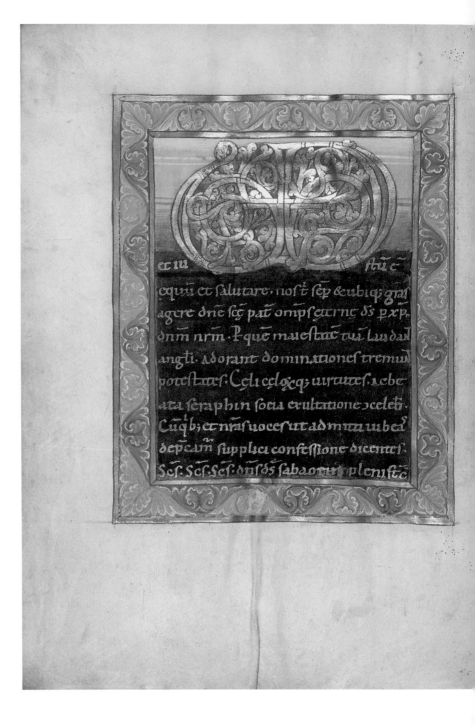

Decorated Incipit Page with Vere Dignum Monogram and Christ in Majesty

Sacramentary, fols. 21v–22
Mainz or Fulda, ca. 1025–50

49

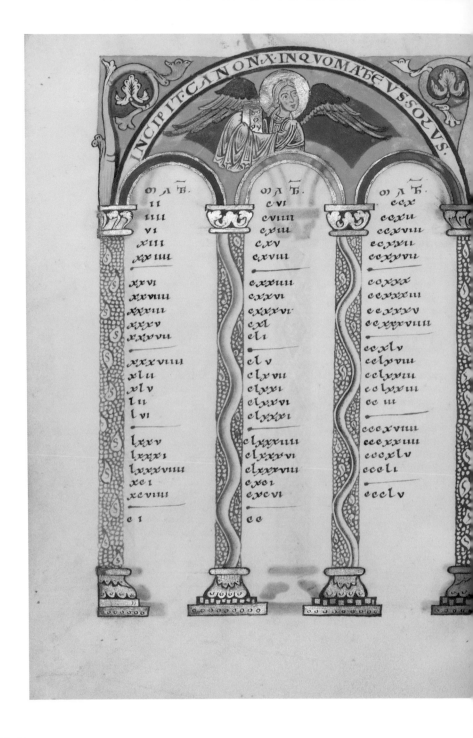

Canon Table Pages

Gospel book, fols. 7v–8
Helmarshausen, ca. 1120–30
Leaf: 22.9 × 16.5 cm (9 × 6½ in.)
Ms. Ludwig II 3; 83.MB.67

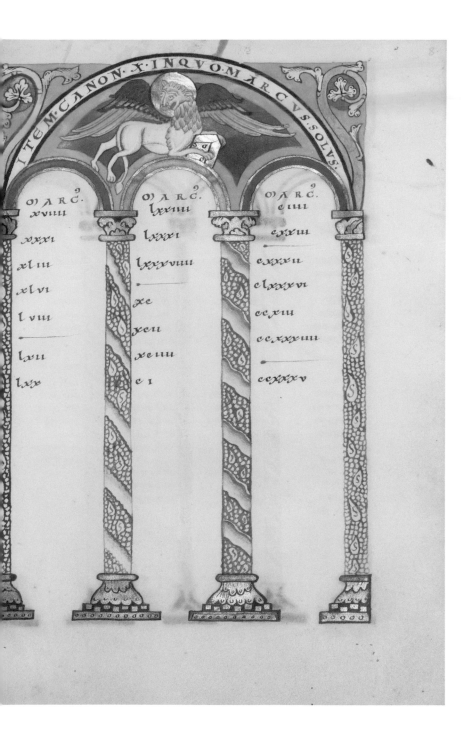

ITEM CANON X INQVO MARCVS SOLVS

⊙ ARC̅.	⊙ ARC̅.	⊙ ARC̅.
xuiiii	lxxiiii	ciiii
xxxi	lxxxi	cxxiii
xel iii	lxxxuiiii	cxxxii
xel ui	xc	clxxxui
l uiii	xcii	ccxiii
	xeiiii	ccxxuiii
lxii	c i	ccxxxu
lxx		

51

Saint Matthew and Decorated Incipit Page

Gospel book, fols. 9v–10
Helmarshausen, ca. 1120–30

June Calendar Page with Junius Brutus (?) and Gemini

Stammheim Missal, fol. 6 (above)
and detail of *fol. 10v* (right)
Hildesheim, ca. 1170s
Leaf: 28.2 × 18.9 cm (11⅛ × 7⁷⁄₁₆ in.)
Ms. 64; 97.MG.21

The Creation of the World and Wisdom

Stammheim Missal, fols. 10v–11
Hildesheim, ca. 1170s

Decorated Text Pages with Vere Dignum Monogram

Stammheim Missal, fols. 84v–85
Hildesheim, ca. 1170s

The Ascension of Christ

Stammheim Missal, fol. 115v
(above) and detail (left)
Hildesheim, ca. 1170s
Leaf: 28.2 × 18.9 cm (11⅛ × 7⁷⁄₁₆ in.)
Ms. 64; 97.MG.21

Saint Michael Battling the Dragon

Stammheim Missal, fol. 152
Hildesheim, ca. 1170s

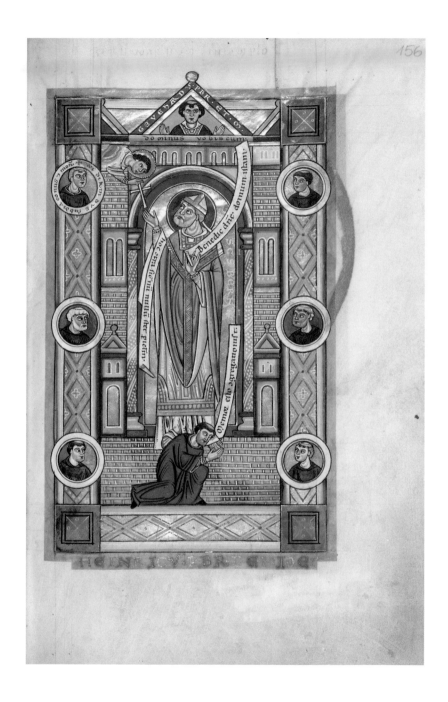

Saint Bernward of Hildesheim

Stammheim Missal, fol. 156
Hildesheim, ca. 1170s

IN NATAL S. MARTINI EPI.

D S · QUI · CONSPICIS
QUIA EX NULLA NRA VIRTUTE
subsistim? concede ppici? ut intcessione be
ati Martini cfessoris tui atq̄ pontificis contra oma
aduersa muniamur. R. SECRETA.

Da misericors ds̄. ut hec salutaris oblatio. & a ppriis nos
reatib? indesinenter expediat. & ab omib? tueat aduer:

P ra q̄s dn̄e ds̄ nr̄: ut cuius festiuitate Compl. fis. R. nobi

uotiua sunt sacramenta. ei nobis salutaria intcessi
one reddantur: R. CODF DIFS. MENNEAR.

RA Q̄S OMPS DS̄. UT QUI BEATI MENNE
mr̄is tui natalicia colim? intcessione ei in tui nomi
nis amore roboremur: R. SECRETA.

Muncrib? nr̄is q̄s dn̄e pcib? q̄ susceptis. & celestib? nos
munda mysteriis. & clementer exaudi. R. Compl.

O aq̄s dn̄e ds̄ nr̄: ut sicut tuox comemoratione scōr̄u.
teporali gratulam̄ officio. ita ppetuo letemur

S QUINOS IN NAT· S. Othmari cf Aspectu. R.
beati Othmari cfessoris tui annua sollepnita
te letificas. concede ppici? ut cui natalicia colim?

Inhabited Initial D

*Leaf from a sacramentary*
Southwestern Germany or
Switzerland, third quarter of the
twelfth century
Leaf: 29.2 × 19.7 cm (11½ × 7¾ in.)
Ms. Ludwig V 3; 83.MF.78

VERNA
T EST NO
BIS ET FILI

datus est nobis cui imperium
sup humerum euis et uocabi
tur nomen euis magni consi
lii angelus. V Cantate do
mino canticum nouum qui
a mirabilia fecit Gloria pa
tri et filio et spiritui sancto.
Sicut erat in principio et nunc
et semp et in secula seculoꝝ
amen. Puer. Collecta.

Inhabited Initial P

Missal, fol. 9v
Premonstratensian abbey
of Steinfeld, ca. 1180
Leaf: 25.2 × 17.9 cm (9¹⁵⁄₁₆ × 7¹⁄₁₆ in.)
Ms. Ludwig V 4; 83.MG.79

Initial T: The Crucifixion

Missal, fol. 67v
Premonstratensian abbey
of Steinfeld, ca. 1180

The Annunciation

Miniature from a psalter, leaf
Würzburg, ca. 1240
Leaf: 17.8 × 13.5 cm (7 × 5 ⁵⁄₁₆ in.)
Ms. 4; 84.ML.84

The Adoration of the Magi

Miniature from a psalter, leaf
(above) and detail (right)
Würzburg, ca. 1240
Leaf: 17.8 × 13.5 cm (7 × 5 5/16 in.)
Ms. 4; 84.ML.84

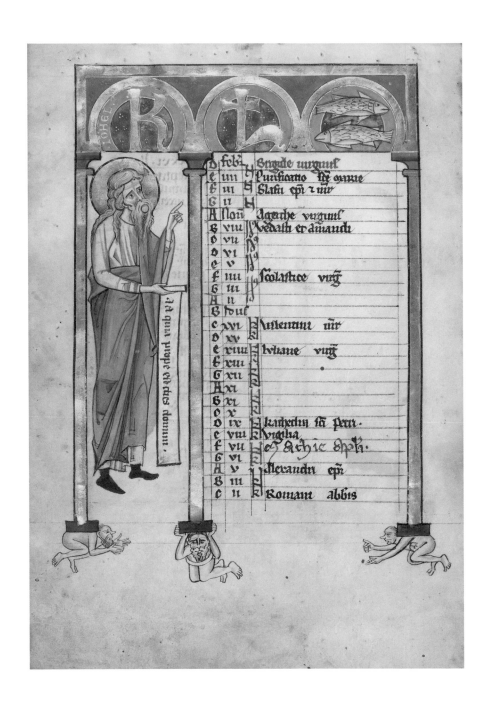

February Calendar Page with Joel

Psalter, fol. 1v
Würzburg, ca. 1240–50
Leaf: 22.7 × 15.7 cm (8¹⁵⁄₁₆ × 6³⁄₁₆ in.)
Ms. Ludwig VIII 2; 83.MK.93

The Tree of Jesse

Psalter, fol. 7v
Würzburg, ca. 1240–50

The Nativity and Habbakuk and Isaiah

Psalter, fols. 8v–9
Würzburg, ca. 1240–50

73

**Initial B: Christ in Majesty and David with Musicians
and Decorated Incipit Page: [B]eatus Vir**

Psalter, fols. 11v–12
Würzburg, ca. 1240–50

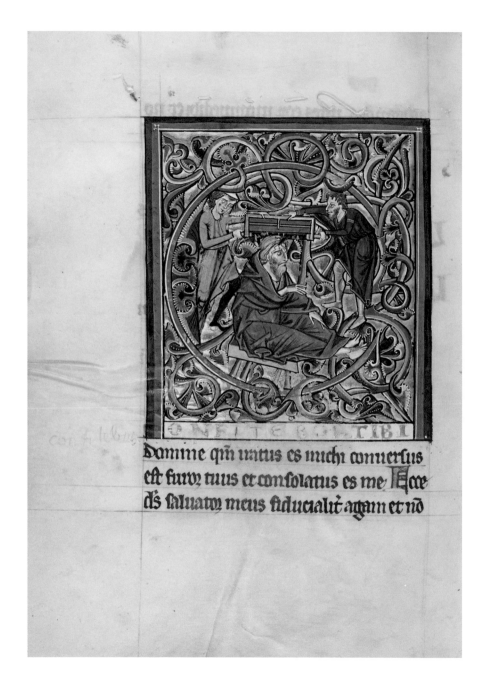

Initial C: Isaiah Being Sawn in Two

Psalter, fol. 161v
Würzburg, ca. 1240–50

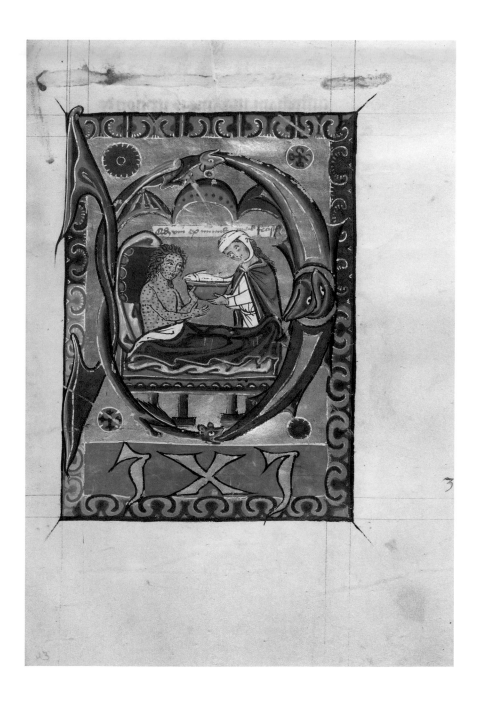

Initial D: A Woman Feeding a Leper in Bed

Psalter, fol. 43
Benedictine abbey of Engelberg,
third quarter of the thirteenth
century
Leaf: 21.6 × 15.6 cm (8½ × 6⅛ in.)
Ms. Ludwig VIII 3; 83.MK.94

Initial G: The Virgin, Saint Elizabeth, and the Infants John the Baptist and Christ

*Historiated initial from a gradual
for the Dominican convent of
Katharinenthal*
Lake Constance, ca. 1300
Leaf: 10.2 × 8.9 cm (4 × 3½ in.)
Ms. 8; 85.MS.77

Initial H: Judith Beheading Holofernes

Peter Comestor, Historia Scholastica,
fol. 211v
Austria, ca. 1300
Leaf: 34.3 × 24.3 cm (13½ × 9⁹⁄₁₆ in.)
Ms. Ludwig XIII 1; 83.MP.144

Initial M: Christ in Majesty

Peter Comestor, Historia Scholastica,
fol. 240v
Austria, ca. 1300

An Angel Presents Christ's Burial Shroud to the Virgin;
The Virgin Shows the Shroud to Saint John

Leaf from Brother Philipp,
Marienleben
Bavaria, ca. 1330–50
Leaf: 32.5 × 22.1 cm
(12 ¹³⁄₁₆ × 8 ¹¹⁄₁₆ in.)
Ms. Ludwig XIII 2; 83.MP.145

Hedwig of Silesia with Duke Ludwig of Liegnitz and Brieg and Duchess Agnes

Vita beatae Hedwigis, *fol. 12v*
(above) and detail (right)
Silesia, 1353
Leaf: 34.1 × 24.8 cm (13⁷⁄₁₆ × 9¼ in.)
Ms. Ludwig XI 7; 83.MN.126

**Hedwig Miraculously Receiving Shoes; Abbot Gunther of Leubus
Presenting Shoes to Hedwig**

Vita beatae Hedwigis, fol. 38
Silesia, 1353

Hedwig and the New Convent at Trebnitz; Nuns from Bamberg Settling at the New Convent

Vita beatae Hedwigis, *fol. 56*
Silesia, 1353

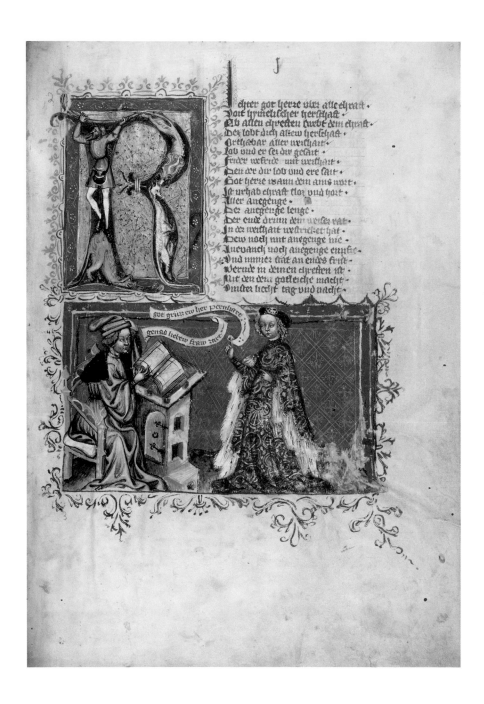

Initial R: Three Dragons and a Man; A Scribe and a Woman

Rudolf von Ems, Weltchronik, *with Jansen Enikel,* The Lives of Job, Alexander, Ezechias, Eraclius, and Nero, *and Brother Philipp,* Marienleben, *fol. 3 (above) and detail (right)*

Regensburg, ca. 1400–1410 (with an inserted full-page miniature added about 1487) Leaf: 33.5 × 23.5 cm (13 3/16 × 9 1/4 in.) Ms. 33; 88.MP.70

Daz der hymel ist genant ·
Nach seiner geschopf wirdichait ·
Die dew hymelisch geschopft trait ·
Vnd da von ler vnd mazze geit ·
An des dritten tages zeit ·

Daz was adam dem got ain weib ·
Macht aus seinen rippen sa ·
Dr was gehaizzen eua ·
Dem macht got mit seiner chraft ·
Vndertan alle geschaft ·

The Creation of the World

Rudolf von Ems, Weltchronik, *with
Jansen Enikel,* The Lives of Job,
Alexander, Ezechias, Eraclius, and
Nero, *and Brother Philipp,*
Marienleben, *fol. 4v* (detail)
Regensburg, ca. 1400–1410

Moses and the Ark of the Covenant

Rudolf von Ems, Weltchronik, *with Jansen Enikel,* The Lives of Job, Alexander, Ezechias, Eraclius, and Nero, *and Brother Philipp,* Marienleben, *fol. 89v* Regensburg, ca. 1400–1410

The Twelve Tribes of Israel

Rudolf von Ems, Weltchronik, *with
Jansen Enikel,* The Lives of Job,
Alexander, Ezechias, Eraclius, and
Nero, *and Brother Philipp,*
Marienleben, *fol. 94*
Regensburg, ca. 1400–1410

Jephtha Telling His Daughter about His Oath

Rudolf von Ems, Weltchronik, *with Jansen Enikel,* The Lives of Job, Alexander, Ezechias, Eraclius, and Nero, *and Brother Philipp,* Marienleben, *fol. 139* (detail) Regensburg, ca. 1400–1410

Alexander the Great in the Air

Rudolf von Ems, Weltchronik, *with Jansen Enikel,* The Lives of Job, Alexander, Ezechias, Eraclius, and Nero, *and Brother Philipp,* Marienleben, *fol. 221* (detail) Regensburg, ca. 1400–1410

The Death of the Virgin; The Punishment of the Mockers

Rudolf von Ems, Weltchronik, *with Jansen Enikel,* The Lives of Job, Alexander, Ezechias, Eraclius, and Nero, *and Brother Philipp,* Marienleben, *fol. 306* Regensburg, ca. 1400–1410

Master of Saint Veronica | **The Crucifixion**

*Miniature, perhaps from
a manuscript*
Cologne, ca. 1400–1410
Leaf: 23.7 × 12.4 cm (9 5/16 × 4 7/8 in.)
Ms. Ludwig Folia 2; 83.MS.49

Master of Saint Veronica | Saint Anthony Abbot Blessing the Animals, the Poor, and the Sick

Miniature, perhaps from a manuscript
Cologne, ca. 1400–1410

Circle of the Master of the Golden Bull | Initial H: Saint Stephen

Leaf from a Benedictine antiphonal
(detail)
Prague, ca. 1405
Leaf: 56.5 × 39.7 cm (22 ¼ × 15 ⅝ in.)
Ms. 97; 2005.33

Circle of the Master of the Golden Bull | Initial D: Melchizedek Feeding
the Armies of Abraham

Leaf from a Benedictine antiphonal
(detail)
Prague, ca. 1405

**Master of the Kremnitz Stadtbuch | The Crucifixion and Master Michael |
Initial T: The Agony in the Garden**

*Missal from the Collegium Ducale,
fols. 147v–148*
Vienna, ca. 1420–30
Leaf: 41.9 × 31 cm (16½ × 12 ³⁄₁₆ in.)
Ms. Ludwig V 6; 83.MG.81

E igitur clementissime
pater per ihm xpm filiu
tuu dnm nrm supplices
rogamus ac petimus:
vt accepta habeas et be
nedicas sup veniuntq;
Dec ☩ dona Dec ☩
munera Dec ☩ sancta
sacrificia illibata In pmis que tibi offerimus
pro ecclesia tua sancta katholica quam pacifica
re custodire adunare et regere digneris. Toto or
be terrarum vna cum famulo tuo papa nro. N. Et
antiste nro. N. Et rege nro. N. Et omnibus or
thodoxis atq; katholice et aplice fidei cultoribus
Memento domine famulorum famulaz q;
tuarum Hic memoretur nomina viuorum.
Et omnium circumstantium quorum tibi fides cogni
ta est et nota deuocio Pro quibus tibi offerim'
vel qui tibi offerunt hoc sacrificium laudis pro
se suisq; omnibus pro redemptoe animaz suaz
pro spe salutis et incolumitatis sue atq; red
dunt vota sua eterno deo viuo et vero Com
municantes et memoriam venerantes In p
mis gloriose semp[er]q; virginis marie genitri

99

Initial A: King David Enthroned

*Missal from the Collegium Ducale,
fol. 7*
Vienna, ca. 1420–30
Leaf: 41.9 × 31 cm (16½ × 12¹⁄₁₆ in.)
Ms. Ludwig V 6; 83.MG.81

Circle of Stefan Lochner | Initial N: Saint James with a Sword

Bible, fol. 406 (detail)
Cologne, ca. 1450
Leaf: 36.7 × 26 cm (14 7/16 × 10 1/4 in.)
Ms. Ludwig I 13; 83.MA.62

Circle of Stefan Lochner | Initial V: Job Derided by His Wife

Bible, fol. 174v
(above) and detail (right)
Cologne, ca. 1450
Leaf: 36.7 × 26 cm (14⁷⁄₁₆ × 10¼ in.)
Ms. Ludwig I 13; 83.MA.62

magno labore conteri · magis utile quod eo
odio meo ecclesiis xpi venturum meus · q̄ ex
alioꝛ negocio Incipit liber Job Cap 1ᵐ

ir erant in terra hus
nomine iob · et erant
vir ille simplex · et
rectus ac timens deū
et recedens a malo ·
Nati que sunt ei septe̅
filij z tres filie · z fuit
possessio eius · septe̅
milia ouiū · et tria
milia cameloꝛ qui
ꝗenta quoque iuga boum · et quingente asine
ac familia multa nimis · Erat que vir ille

tatione pñti. qua me mdesmet emul
lauiant ipē michi ī futurū mercede restit
at. qui sit me ob hoc ī pereñ ne ligue e
diaone sudasse. ne uidei de falsitate si
turur ercaijs eius ductius insultarent.
Explicit ploqius Incipit liber ysaye ppht

sio ysaie filij am
qua uidit sup
r iherlm in dieb
one ioathan ac
et ezechie regu
da. Audite celi
auribz pape ti
huoma dñs lo
tus ē. filios et
trui exaltaui

Circle of Stefan Lochner | Decorated Initial V

Bible, fol. 235
(above) and detail (left)
Cologne, ca. 1450
Leaf: 36.7 × 26 cm (14⁷⁄₁₆ × 10¼ in.)
Ms. Ludwig I 13; 83.MA.62

Workshop of Diebold Lauber | **King Avenir Hunting Wild Boar**

Rudolf von Ems, Barlaam and
Josaphat, *fol. 12*
Haguenau, 1469
Leaf: 28.6 × 20.3 cm (11¼ × 8 in.)
Ms. Ludwig XV 9; 83.MR.179

Workshop of Diebold Lauber | The Brother of King Avenir Speaking with Josaphat

Rudolf von Ems, Barlaam and
Josaphat, *fol. 36*
Haguenau, 1469

Workshop of Diebold Lauber | The Prodigal Son at the Brothel

Rudolf von Ems, Barlaam and
Josaphat, *fol. 106*
Haguenau, 1469

Workshop of Valentine Noh | Initial C: The Nativity

Prayer book, fol. 72
Prague, ca. 1470–80
Leaf: 14.1 × 10.2 cm (5 ⁹⁄₁₆ × 4 in.)
Ms. 28; 87.ML.60

Workshop of Valentine Noh | Initial C: The Agony in the Garden

Prayer book, fol. 119v
Prague, ca. 1470–80

Workshop of Valentine Noh | Decorated Initials S and G

Prayer book, fol. 260v
Prague, ca. 1470–80

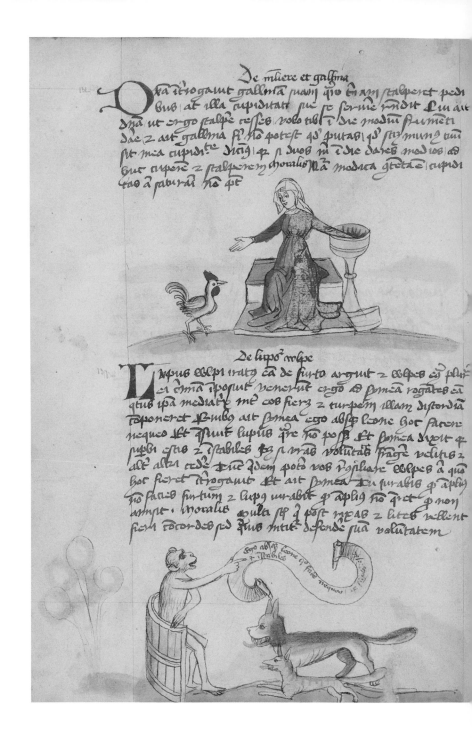

A Woman with a Vessel and a Hen; A Monkey Instructing a Fox and a Wolf, and A Crab and Its Mother; A Man Hitting a Donkey

Fables and moral-theological writings, fols. 48v–49
Probably Trier, ca. 1450–1500
Leaf: 28.7 × 20.6 cm (11⁵⁄₁₆ × 8⅛ in.)
Ms. Ludwig XV 1; 83.MR.171

matre
De Cancro et uxore eiꝰ

Ancer ꝛtroꝶꝺꝰ doꞃſu ſuū ⁊ lapꝺoꝛis locus attriuit que
vt mꝰ pꝺa vdit dꝛpt aꝛuoꞃ ſﬁ ꞓ hoꞓ deꝛſa ꝛꝼꞇ
cu rꝺꝛ vtiꝺ ꞇꝛaꝺꝛ debere deꝶſte erꝺo de ꝺꝛo auꝺa faꞇꝛ
ꝛꝺꞇaﬁa ne tꝺꝶecta noꞇeat ꝺꝛpt avaꝺa ſacꝺa ꞇꝟt faꞇ q hoꞓ
tarꝺs ⁊ matꝛꝺs aꞇꝶꞇeꞇam moꞇitus ꝓ te vt dꝺas ꝛꝺ veꞇ
ꝺo ꝓ abulaꞇ vdꝺo ꝺꝶꝺ ꝺꝛꝺ doꞃ ⁊ eꝶo te vt mꝺꝺ ꝓꝶꝺ
ꝺꝺ ꝺus vꝺ tua ⁊ hoꞓ ꝺꝺ aꝶꝶt ꞇꝺꝺa ꝶꝺ ea ꝺꞇꝛus qꞇu
ꝺꝛe ꝺ ꝺo potꝶs ꝺ nꝺꞇus ꝺꝺmꞇꝺ Fabula ꝺſta illus tꝶꞇ
ꞅꞇ dꝶꝶꞇꝺ
ꝓ aliena aꝶꝶꞇꝺ ꝟꝺa tꝺ vꝺ ta macꞇꝺus ⁊ maꝺꝺꝺtus
ꝺo caꝛeat ꝓꝟꝺtatꝺs ꝺꝺ maꞇꞇꞇa ꝓede꞉ꞇꝺs ꞅꞇ ꞇonꝺmaꞇ ꝺaꞇꞇ
ꝺꝺt ꝟꝺa ꝺ ꝺꞇs dꝺꞇꝛꞇa ꝺo ꝓꞇꞇ ꝺꞇꝟꞇ
ꝺeꞇꞇꞇa

verte folin

Zů dier ſtritten vn̄ mänſchlichkeit
pin ich berait alß ich es zaig
meine claid vn̄ meine kind machet mächt ha
ſie wiſſent wie ward oder waß

The Planet Mars as an Armored Knight on Horseback

Astronomical miscellany, fol. 48v
(detail)
Ulm or Augsburg, shortly after 1464
Leaf: 30.6 × 22.1 cm (12 ¹⁄₁₆ × 8 ¹¹⁄₁₆ in.)
Ms. Ludwig XII 8; 83.MO.137

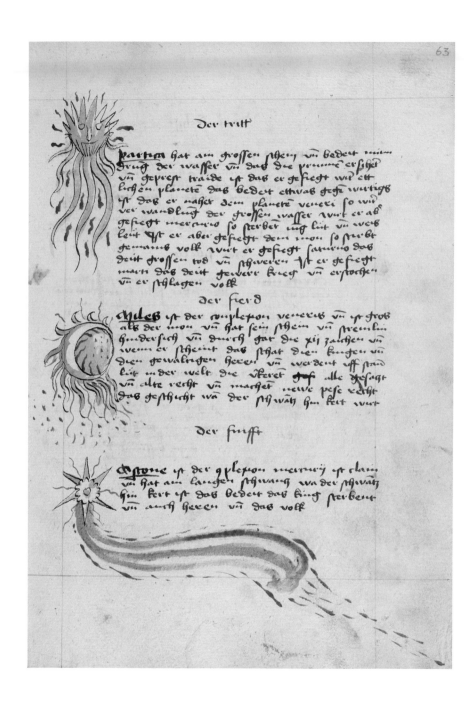

Der tritt

Sarturn hat ain grossen schein vñ bedeut min trueg der wasser vñ das die prunne ersticst vñ geprest traide ist das er gesiecht wild ett lichen planete das bedeut ethwas gesti wirtigs ist das er naher dem planete veneri so wird ver wandlung der grossen wasser wirt er ab gesiecgt mercurio so sterben iung liit vñ web leut ist er aber gesiecgt dem mon so sterbt gemains volk wirt er gesiecgt sanurs das deit grossen tod vñ schweren ist er gesiecgt mars das deit tenerr krieg vñ ersticken vñ er schlagen volk

Der fierd

Miles ist der vergleichon veneris vñ ist groß als der mon vñ hat sein schein vñ streinlin hinderssich vñ durch gar die xij zaichen vñ wenn er scheint das sthat dien kungen vñ dien gewaltigen herren vñ werdent uff stand liig in der welt die ubernt gar alle gesagt vñ alte recht vñ macher newe pese recht das gesthicht wa der schwaz hin kert wirt

Der funfft

Astone ist der vergleichon mercurij ist klain vñ hat ain langen schwanz wa der schwaz hin kert ist das bedeut das king sterbent vñ auch herren vñ das volk

Comets

Astronomical miscellany, fol. 63
Ulm or Augsburg, shortly after 1464

The Crucifixion

*Miniature, perhaps from
a manuscript* (above) and
detail (left)
Probably Franconia, ca. 1475–1500
Cutting: 38.9 × 24.3 cm
(15⁵⁄₁₆ ×9⁹⁄₁₆ in.)
Ms. 52; 93.MS.37

Probably workshop of Ulrich Schreier | Initial B: David in Prayer

Diurnal, fol. 17v
Salzburg or Vienna, ca. 1485
Leaf: 17.6 × 13 cm (6¹⁵⁄₁₆ × 5⅛ in.)
Ms. Ludwig IX 14; 83.ML.110

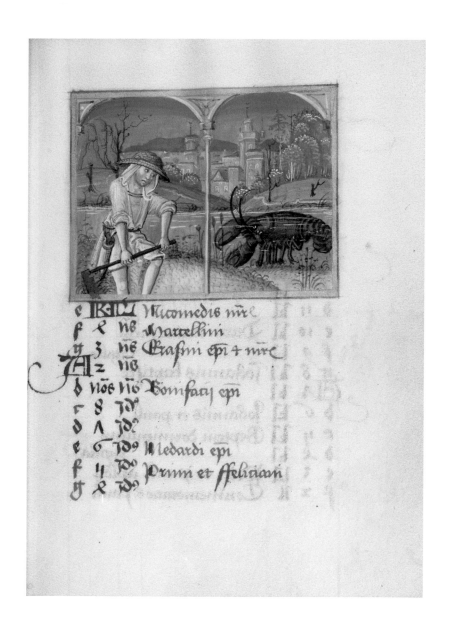

June Calendar Page with Mowing and Cancer

Book of hours, fol. 6
Strasbourg, early sixteenth century
Leaf: 13.5 × 10.5 cm (5 5/16 × 4 1/8 in.)
Ms. Ludwig IX 16; 83.ML.112

The Visitation

Book of hours, fol. 165v
Strasbourg, early sixteenth century

Decorated Initial A

Missal, fol. 6
Westphalia, ca. 1500–1505
Leaf: 38.7 × 27.9 cm (15¼ × 11 in.)
Ms. 18; 86.MG.480

The Crucifixion and Decorated Initial T

Missal, fols. 157v–158
Westphalia, ca. 1500–1505

In primis q̄
tibi offerimus
pro ecclia tua
sancta catholi
ca. quā pacifi
care custodire
adunare τ rege
re digneris to
to orbe terrarū
vna cū famu
lo tuo papa
nᷓo. N. et an
tistite nᷓo. N.
et rege nᷓo. N.
et omnibus
orthodoxis at
q̄ catholice et
apostolice fidei
cultoribus.

Te igitur clemen
tissime pater.
per ihm cristi
filiū tuū dnm
nᷓm supplices
rogamus ac
petimus. vti ac
cepta habeas
et bndicas Hec
✠ dona Hec ✠
munera Hec
sancta sacrifi
cia ✠ illibata.

Armor

Tournament book, fol. 2v
(above) and detail from *fol. 46v*
(right)
Probably Augsburg, ca. 1560–70
Leaf: 43 × 28.9 cm (16¹⁵⁄₁₆ × 11⅜ in.)
Ms. Ludwig XV 14; 83.MR.184

A Drummer and a Flute Player on Horseback and Two Horsemen with Lances

Tournament book, fols. 46v–47
Probably Augsburg, ca. 1560–70

Jörg Ziegler | Rudolf Hohenzollern

*Chronicle of the Hohenzollern
family, fol. 9*
Probably Augsburg or Rottenburg,
ca. 1572
Leaf: 35.2 × 27.8 cm (13⅞ × 10¹⁵⁄₁₆ in.)
Ms. Ludwig XIII 11; 83.MP.154

Georg Strauch | The Twenty-seventh Generation, Christoph Derrer and His Second Wife Ursula Scheuerlin, Dated 1641

Genealogy of the Derrer family, fol. 128bis v
Nuremberg, ca. 1626–1711
Leaf: 37.6 × 26 cm (14¹³⁄₁₆ × 10¼ in.)
Ms. Ludwig XIII 12; 83.MP.155

A Ship in a Stormy Sea

Genealogy of the Derrer family,
fol. 129v
Nuremberg, ca. 1626–1711

The Nuremberg Residence and Garden of Magdalene Pairin

Genealogy of the Derrer family,
fol. 130bis
Nuremberg, ca. 1626–1711

Published by the J. Paul Getty Museum

Getty Publications
1200 Getty Center Drive, Suite 500
Los Angeles, California 90049-1682
www.getty.edu

Gregory M. Britton, *Publisher*
Mark Greenberg, *Editor in Chief*

Patrick E. Pardo, John Harris, and Jesse Zwack, *Editors*
Robin Ray, *Manuscript Editor*
Vickie Sawyer Karten, *Series Designer*
Jeffrey Cohen, *Designer*
Amita Molloy, *Production Coordinator*

Photography and digital imaging supplied by Stanley Smith, Rebecca Vera-Martinez, Michael Smith, and Chris Allen Foster of Getty Imaging Services.

Color separations by Professional Graphics Inc., Rockford, Illinois
Printed and bound by CS Graphics Pte Ltd., Singapore

Library of Congress Cataloging-in-Publication Data
J. Paul Getty Museum.
 Illuminated manuscripts of Germany and Central Europe in the
J. Paul Getty Museum / Thomas Kren.
 p. cm.
ISBN 978-0-89236-948-5 (pbk.)
1. Illumination of books and manuscripts, German—Catalogs.
2. Illumination of books and manuscripts, Central European—Catalogs.
3. Illumination of books and manuscripts—California—Los Angeles—
Catalogs. 4. J. Paul Getty Museum—Catalogs. I. Kren, Thomas, 1950–
II. Title.
ND3151.J24 2009
745.6'7094307479494—dc22

 2008033824

5 4 3 2 1

Front cover: *Hedwig of Silesia* (detail, pages 82–83)
Back cover: *The Presentation in the Temple* (detail, page 44)
Frontispiece: *Saint Michael Battling the Dragon* (detail, page 62)
Page 4: *Initial A: King David Enthroned* (detail, page 100)
Page 6: *Decorated Incipit Page* (detail, page 53)
Page 13: *Christ in Majesty* (detail, page 49)
Page 16: *Saint Matthew* (detail, page 52)
Page 21: *Initial B: Christ in Majesty and David with Musicians* (detail, page 74)
Page 26: Master of Saint Veronica, *The Crucifixion* (detail, page 94)
Page 29: *Jephtha Telling His Daughter about His Oath* (detail, page 91)
Pages 34–35: *Moses and the Ark of the Covenant* (detail, page 89)